£3.00

D1274068

*A Facsimile Reprint
Published by Cornmarket Press
London 1970*

Published by Cornmarket Press Limited
42/43 Conduit Street, London W1R 0NL
Printed in Switzerland by Reda S.A.
ISBN 0 7191 2094 2

INTRODUCTION

André Rouquet was born at Geneva on 13 April 1701. His father's name was Jacques, his mother was born Françoise Saulier. The family were refugee French Protestants, possibly from Montpellier.[1] The influx of Protestant craftsmen on the Revocation of the Edict of Nantes had made Geneva a centre of enamel painting, and Rouquet learnt the craft in his native city. As a very young man he went to Paris, and then came c. 1722[2] to London, where he practised as a painter of portrait miniatures in enamel until the autumn of 1752. For almost two centuries the portrait miniature had been a favourite art-form in England, and it was at the Court of Charles I that Jean Petitot, a goldsmith of Geneva, first

[1] E. & C. Haag, La France Protestante, ix, 1859, p. 21. The name Jean, sometimes prefixed to André, does not appear in any contemporary source. A Huguenot family named Rouquet was settled in England from c. 1700, but the published records of the Huguenot Society do not contain any mention of André or anything which suggests that he was related to these other Rouquets.

[2] He says that he had lived for thirty years in England: since he is known to have gone to Paris in 1752, the date c. 1722 can be deduced accordingly.

*perfected the application to the portrait-miniature of the technique of painted enamel. In the 18th century the smooth softness and brilliancy of enamel were still much admired, and the Dresden-born Christian Friedrich Zincke (1683-1767) who came here in 1706, was kept busy painting persons of distinction for most of his professional life. Painted enamel, a difficult, but durable technique, then demanded great empirical knowledge of the chemistry of colours, and Rouquet gives an admiring description of Zincke's ability to make his enamel-colours rival oils in fluency of effect. Rouquet applied himself to the study of the chemistry of colours and for this purpose, like many enamel painters, made friends with chemists, even, it seems, with alchemists. He is said to have acquired precious secrets, and certainly the few portraits by him that survive—the gold on which enamel miniatures are painted often shortened their existence in the 18th century—are very accomplished. In 1739 Vertue noted "of late years since M*r* Zincke Enameller has had so much imployment amongst the Nobility & at Court and has raised his price from 10 to 15. or 20 guineas a small head which is his price now—others have endeavourd to immitate and follow him close, particularly . . . Rocquet Enameller has best succeeded. and now is*

INTRODUCTION

*much imployd . . . and at this present has 10 guineas
a head." He was still in high vogue in 1749.*[1]

*Rouquet is said to have frequented Garrick,
Foote, and "the wits of the day". He was above
all a friend and companion of Hogarth, to whom
his sharp wit, lively humour, sturdy independence
and honest warmth of temper probably endeared
him. He also shared or allowed himself to be in-
spired with Hogarth's pugnacious views on the
evils of English artistic life, though it seems un-
likely that he too had suffered from connoisseurs
and dealers. Rouquet was Hogarth's near neigh-
bour, for he lived at the Golden Head in a street
south of Leicester Fields, where Hogarth had a
house. The Golden Head was to become notorious
some years after Rouquet had left England, for in
1761 Theodore Gardelle (1722-61) another
enamel-painter from Geneva, murdered its land-
lady, Anne King.*

*In 1745 Rouquet wrote for Hogarth an ex-
planation of his prints in French, then the universal
language of the Continent. Hogarth himself
recorded c. 1753 that it was begun only "for the
amusement of Marchal Belile and his br then
Presoners in England who having bought my
whole set M.* Rouquet haveing then been in*

[1] *The Walpole Society*, Vertue Note Books, *iii, 1934, pp. 96, 152.*

INTRODUCTION

England many years and well acquaint[ed] with the manners and characters of y^e English was req[uested] after having verbally explained my Prints to them of me to [put] particulars in writing that they might at leasure have recourse to th[em] which he afterwa[rds] communicated to me."

Hogarth's prints were "going much abroad per[haps] to foreign courts" and "I was struck with the use such an Explanation in French might be to such abroad as purchased my prints and were unacquainted with our characters and manners. and thereupon desire'd . . . the favour of him to write an Explanation somewhat more fully than was necessary for a Private perusal". At Hogarth's request Rouquet changed his descriptions "into familiar letters as to a friend at Paris."[2]

The conception of the scheme can be dated fairly exactly. Charles-Louis-Auguste Fouquet, Maréchal de Belle-Isle (1684-1761) was captured in Hanover with his brother the Chevalier de Belle-Isle on 20 December 1744. The two were brought to England on 11 February 1745, and kept prisoner at Windsor until early April, when they were given permission to move freely on

[2] W. Hogarth, The analysis of beauty, *ed. J. Burke, Oxford, 1955, pp. 230, 188, 229.*

INTRODUCTION

parole *within ten miles of Windsor provided they
did not come within five miles of London. Late in
April the Maréchal took a house at Frogmore,
where he lived until he left England on 24 August.
With the* Lettres de Monsieur xx à un de ses
Amis à Paris, Pour lui expliquer les
Estampes de Monsieur HOGARTH, *pub-
lished anonymously in April 1746, Rouquet em-
barked on his career as an interpreter of English
art to Europe and especially to France. George
Steevens, writing in 1782, says "On the present
occasion he was liberally paid by* Hogarth, *for
having cloathed his sentiments and illustrations in
a foreign dress". If Steevens is to be believed,
Hogarth gave Rouquet "some of the circumstances
explanatory of the plates", and left him to fill in
the rest, whence the "entire performance . . . in my
opinion, exhibits very strong marks of the vivacious
compiler's taste, country, and prejudices. Indeed
many passages must have been inserted without the
privity of his employer, who had no skill in the*
French *language. That our* clergy *always*
affect to ride on white horses, *and other re-
marks of a similar turn, &c. &c. could never
have fallen from the pen of* Hogarth, *or any other*
Englishman."[1] *The three letters explain, with*

[1] *In J.* Nichols, Biographical Anecdotes, *ed. of 1782*, pp. 92-4.

appropriate moralising, The Harlot's Progress, The Rake's Progress *and the* Marriage a la Mode. *A postscript at the end of the third briefly describes nine other prints. Rouquet's account of London life is lively and brisk, with the touches of strong realism to be expected from an admirer of Hogarth and Fielding, though softened to meet the exigencies of French taste. Rouquet was no mere mouth-piece for Hogarth. He expresses a certain pessimism about the possibility of reforming the vices of mankind, believing them to be innate: nevertheless he thinks it laudable to attempt reform, and folly is the legitimate province of satire. Not all the accounts of English customs and habits are very favourable—how could they be?— and Rouquet takes discreet exception to Hogarth's portrayal of the French quack in Plate III of the* Marriage a la Mode. *Yet his unkind remarks about auctions and picture-dealers certainly echo Hogarth's opinions. Naturally Rouquet's independence did not please; Walpole tartly characterised his little work as "superficial". It has none the less always been indispensable even to learned interpreters of Hogarth, and its deft and vivid explanations could hardly be bettered as a brief guide for a foreigner.*

Early in 1750 Rouquet added a fourth letter,

entitled Description du Tableau de M. HOGARTH Qui REPRESENTE LA MARCHE des Gardes à leur rendez-vous de-Finchley, Dans leur Route en Ecosse. *A note beneath the title informed the reader that "Cette Lettre de Mr. Rouquet, connu par ses Ouvrages d'Email, a été écrite à un de ses amis à Paris, pour l'amusement & peut-être par les ordres d'une personne très-distinguée, qui se trouvoit à Londres lorsqu'il commença d'écrir e celles qui ont déjà paru sur les autres Ouvrages de Mr. Hogarth". The letter was written after the painting had been finished (by 16 March 1750) but before it was engraved (May-December 1750), and was evidently published as a puff to attract orders for the print from abroad. Rouquet opens with a tilt against the connoisseurs; The* March, *he says slyly, has a fault; Time has not yet obscured it with a "docte fumée", and it shines with all that "ignoble fraîcheur, qu'on découvre dans la nature, & qu'on ne voit jamais dans les Cabinets bien célébres" a passage re- peated word for word in the French edition of the book reprinted here. In Rouquet's vivacious description comes the odd hit at the English, and the national Gallophobia is smartly knocked; Hogarth's own knuckles are rapped for it. The four*

INTRODUCTION

letters were combined into one pamphlet[1] which Hogarth always despatched abroad with sets of his prints. As late as 1782 it was still being so used.[2]

Rouquet left England for Paris in the autumn of 1752, but still continued anxious to serve his friend. In a letter to Hogarth of 22 March 1753 he enquires about the forthcoming Analysis of Beauty.

Dear Sir,

I expected to have been in England about this time, but find my self disapointed by the tediousness of the progress of what I have began, & business coming in very smartly I believe I shall stay here some months longer than I proposed at first. therefore shall indulge my self with the pleasure of writing these till I injoy that of your conversation. [I] have a thousand observations to impart to you when

[1] *An English translation made in the 18th century is bound up with other Hogarth material in Add. MSS. 27,994 as ff. 1-19.*

[2] *Nichols,* loc. cit. *Steevens says the fourth letter was added while the first three were going through the press. The fact of separate publication is established by (1) The note beneath the title, (2) Separate pagination and a different typography, (3) The first three letters were reprinted as a complete work in 1748 in the* Bibliothèque choisie et amusante *(iii, Amsterdam), (4) A reference to* Tom Jones *(first published February 1749). A date c. 1750 is proposed in A. Dobson,* William Hogarth, *London, 1907, p. 158, and accepted by R. Paulson,* Hogarth's Graphic Works, *i, London & New Haven, 1965, p. 277-80.*

INTRODUCTION

we meet, some that, will please you, some that
you will think inacurate but all such as will
not allow us time to gap [sic] when we see on
another. first I hope you are in perfect health &
the next news I want to hear is when your book
is to be publish'd. I have rized some expecta-
tions about it amongst artists & virtuosy
here, & hope to have the first that shall come
over. that I may boast of your acquaintance by
being the first usher of a performance which I am
sure will make many people whish they were
acquainted with you. The humbug virtu is
much more out of fashion here than in England,
free thinking upon that & other topicks is more
common here than amongst you if possible, old
pictures & old stories fare's a like, a dark
picture it becomes a damn'd picture as the soul
of the Dealer. & consequently modern per-
formances are much incouraged. & mine
amongst them, for they have met with a re-
ception much beyon what I expected, & they
deserved. that circumstance has made Paris
more agreeable to me than it would have been
without it. I pass my time in it very swiftly &
perpetualy imploy'd, in a great variety of un-
avoidable business the days succeed one another
with great rapidity. Nevertheless I think I dont

*injoy so good a health as England tho I was
often ill there, but the hurry I have been in
these 6 months, which can not be discribed,
may be the occasion of it I am afflicted with a
continual head ake which I had not been subject
to, these five & twenty years, & which if it
should not abate will occasion my return, before
business admits, I supose you have by this
time some spring days at Ivy hall. I shall have
no contry air this year, but am a going to loge
in the most open part of the Town which I
hope will do instead. that is upon the* quai de
conty *next to College Mazarin. where I shall
be in three weeks ready to receive the answer
that I beg you will favour me with.*

 I am Dear Sir,
 Your most humble servant
 Rouquet

Paris March the 22
 1753
*My respects to M*ʳˢ *Hogarth.*[1]

*Though Rouquet did not at first intend to settle
in France, the three portraits he exhibited at the
Salon of 1753 made a sensation, and the most*

[1] *This letter was first published by John Ireland,* Hogarth Illustrated, *iii, 1798, pp. 126-8. Ireland altered the spelling, punctuation and some of the wording, as well as omitting the postscript. I have transcribed the original from Add. MSS. 27,995, ff. 12-13.*

flattering measures were taken to fix him in Paris by the Marquis de Marigny (1727-81) Madame de Pompadour's brother and as Directeur et Ordonnateur des Bastiments, des Jardins, Arts, Académies et Manufactures Royales the most powerful dispenser of government patronage in France. In August the Académie de Peinture accepted Rouquet into its number, on 23 February 1754 the King confirmed his membership, though Rouquet was a Protestant[1], and his official reception took place on 23 December 1754. On 21 July 1754 he received the coveted honour of a logement in the Louvre[2]. An important contemporary critic, Lafont de Saint-Yenne, declared: "La beauté des portraits qui ont paru de lui au salon de 1753, ont fait augurer qu'il remplacera le célèbre Petitot."[3]

Rouquet found the French, in spite of their anglomania, not very accurately informed about things English. It was to substitute the truth for excessive praise and denigration that he wrote L'Etat des Arts en Angleterre. *Probably begun in 1753, it was completed in 1754 and*

[1] *L. Dussieux, "Académie de Peinture et de Sculpture," in* Archives de l'Art Français, *i, 1851-2, p. 389.*

[2] *J. J. Guiffrey, "Logements d'artistes au Louvre", in* Nouvelles Archives de l'Art Français, *1873, p. 92, No. 141.*

[3] Sentiments sur quelques ouvrages de peinture, *1754, quoted in F. Reiset,* Notice des dessins . . . du Louvre, *ii, 1869, pp. 446-8.*

appeared early in 1755, with a dedication to Marigny, whose portrait, executed for the Académie, Rouquet exhibited at the Salon that same year. The head-piece (dated 1754) to the preface was engraved by one of Rouquet's earliest and best friends in France, Charles-Nicolas Cochin fils *(1715-90) engraver to the King, royal censor, secrétaire perpétuel of the Académie de Peinture, and keeper of the royal collection of drawings. A portrait of Cochin was one of the three Rouquet had exhibited in 1753.*

The subject of the arts in England had already been much discussed in France. So early as 1719 the Abbé Du Bos, in marking out ground for his theory that national genius in the fine arts is fecundated largely by physical causes, in particular climate, had pointed to England as a country where paintings had been eagerly admired and collected for two hundred years, but which had not produced a single painter of the first or second rank. Every artist of distinction who had worked there had been a foreigner. Even in ornamental art, though English workmanship was excellent, English design was poor. The climate was certainly warm enough to produce illustrious philosophers, scholars, poets and other learned men, but it was too cold and damp for the fine

INTRODUCTION

arts.[1] *This opinion the Président de Montesquieu was happy to share. Voltaire, whose* Lettres Philosophiques *(1733-4) really initiated French anglomania, was only interested in English religion, science, government and literature and Rouquet had but to praise his characterisation of Shakespeare and to rectify him on the subject of Newton's tomb.*

Rouquet's aversion among French authors was the Abbé Jean-Bernard Le Blanc (1706-81), a littérateur whose Lettres d'un François, *published at Paris in 1745, describe England after observations made during the Abbé's residence here from February 1737 until July 1738 as a guest of the Duke of Kingston. Translated into English in 1747 and later into other languages as well, they reached a fifth French edition by 1758 and were regarded as a standard work. The letters are imaginary, though they purport to be written to the author's friends, who included such distinguished personages as Buffon, Maupertuis and Montesquieu. The Abbé fancied himself as a critic and connoisseur and his Letter XXIII discusses the state of the arts in England. It is addressed to Du Bos, whose*

[1] Réflexions critiques sur la poësie et sur la peinture, *ii, Paris, 1719, pp. 143-5.*

views Le Blanc flatteringly echoes. The picture he paints is gloomy. The arts of design have been shockingly neglected by the English. In spite of the splendid collections and lively interest of the nobility, whenever the seed of the fine arts is planted here it perishes, strangled by the bad taste of English artists and craftsmen. London, it is true, has no Academy, unlike Paris, but academies cannot teach more than the elements of drawing. Even the best London goldsmith is only a craftsman, whereas Germain and Meissonier are designers and sculptors. English taste in sculpture is poor. As for painting, only Thornhill has attempted grandiose compositions, but the question is to decide which parts of them are the least bad. English portrait painters care only for money, and practice their noble profession as if it were a vile mechanic trade. Monotonous in pose, monotonous in colouring, flatly painted, their portraits differ only in the heads, which are stuck on the same unvarying trunks. English painters have just as little talent for satire or burlesque even though they practise them much more. Their humour in painting is like their humour in litera-ture, cold, heavy and overdone: even their satirical prints against government, which appear daily, are coarse and crude. In the grotesque style invention

is not enough; the artist must know where to stop, and the English never do. Besides, their taste differs from French taste; it is not offended by low and disgusting objects, and perhaps by nature the English are less refined and delicate than southern peoples. Yet it must be confessed that English burlesque painters ennoble their art by employing it to make Vice appear hideous. Truly astonishing is the circulation that " a set of prints actually have in England, engraved lately from pictures of a man of genious in this way, but who is as bad a painter, as he is a good subject. They have made the graver's fortune who sells them; and the whole nation has been infected by them, as one of the most happy productions of the age. I have not seen a house of note without these moral prints, which represent in a grotesque manner the Rake's Progress in all the scenes of ridicule and disgrace, which vice draws after it."[1]

Rouquet was not the only person offended by Le Blanc. Dr. James Parsons sprang to the defence of English art: "it is notorious." he wrote in the preface to his Human Physiognomy Explain'd *(1746) "that our Youth have made as good a Figure in foreign Academies as any that were educated at them; and we have even had*

[1] *From the English translation of Le Blanc (i, London, 1747, p. 162).*

some, who by dint of Genius, have born away the Prize[1] *from those of every other Nation." The Abbé replied to Parsons in 1751 and again in 1757*[2] *repeating his charge that the English had made only feeble progress in painting and taking Richardson to task for advancing the contrary. Le Blanc's long, severe and pointed criticism of Hogarth partly explains the lengthy account Rouquet gives in his book of his friend's art and theories. His ire must indeed have been roused, for he was not restrained from attaching the Abbé by the fear of offending Marigny, whom Le Blanc, together with Cochin and Soufflot, had accompanied on his great study tour of Italy from December 1749 until September 1751. It was, moreover, no less a person than the Marquise de Pompadour who had obtained the Abbé's appointment in 1749 as Historiographe des Bâtiments du Roi. Yet ironically Hogarth agreed with the Abbé in despising the tricks of English portrait painters, and it is the animosity of Hogarth which must account for something of Rouquet's delightfully satirical account of their ways.*

Rouquet, as the reader will discover, had his own general theories of the origin and progress of

[1] *The allusion is to William Kent.*

[2] *In the prefaces to the editions of 1751 and 1758 (preface dated 1757).*

the arts as well as views on their present state in England. A citizen of the industrious Republic of Geneva, he respects only artificers, as being the producers of goods. Aristocrats he regards as idle consumers, and they find little grace in his eyes. Merchants find even less, which is surprising in an author of Rouquet's period and background, and he attacks them fiercely as exploiters. The contrast between this opinion and Voltaire's loud admiration of the English merchant is marked. Rouquet attributes the low state of the arts in contemporary England to two causes, one natural, the predominance of the judgement over the imagination in the English temperament, the other social, the increased absorption of the English in trade, and the waning of royal power and patronage. Because of the exclusive pursuit of wealth, there is an exclusive reverence for rank and fortune in England, and artists have been deprived of their legitimate standing. There is no state patronage of the arts, nor is there likely to be in a country whose government gives places solely with a view to election votes. State neglect of the arts was of course deplored in England too: so in 1737 a newspaper paragraph lamented: "About two hundred paintings, and other prize pieces, of the Academy of Painters at Paris, are daily visited

INTRODUCTION

by the curious of all nations at the Louvre. What a discouragement it is to the ingenious men of Great Britain, that we have no annual prizes to reward their pains and application."[1] *Rouquet also adds that the English look on pictures and works of art merely as decorations, rather than as high art, a state of mind already attacked by Richardson in 1719, and if anything even more prevalent in mid-Georgian England. And he expresses appreciation of the good effects of French state patronage, partly no doubt because he himself had found it prompt and liberal.*

Rouquet's little book is the only contemporary survey of English art during the two obscure but important decades from 1730 to 1750, so it is fortunate that he lived here long enough to be well informed, and was impartial, as well as lively and intelligent. He not only writes about the fine arts, but about the applied and decorative arts as well. Since these are so important in the eighteenth century, their inclusion is one of his best legacies to posterity. To account for it, besides that general interest of the Enlightenment in crafts and manuactures so monumentally expressed in the En-cyclopédie, there is the particular nature of

[1] *Quoted by J. Pye,* Patronage of British Art, *London, 1845, p. 44, n. 44.*

INTRODUCTION

enamel-painting, which touched on both the fine and the decorative arts, having close links with goldsmiths' work and jewellery as well as with painting. Rouquet also includes some interesting chapters on English style in speaking and acting and on English music, cookery and medicine. Into literature, a hornet's nest of critics, he wisely did not venture.

Rouquet's taste in painting was that of his place and generation: he disliked the gloom of Baroque religious painting and avows his preference for a smiling, cheerful, decorative art. In portraiture, his own line, he objects to the representation of active poses and fleeting expression—a French, rather than English practice. A portrait for him is a permanent record, and should depict the sitter in natural, easy pose and expression. In the decorative arts he enters a strong objection against the systematic asymmetry of the Rococo (which he terms "baroque") style that had been dominant in England since its importation from France in the early 1730s. Here he is surely echoing the views of his patron Marigny and his friend Cochin, who had returned from their Italian tour with an antipathy to the Rococo. But Rouquet does not echo the determination of his French friends and patrons to replace "le mauvais goust d'ornemens"

by the Neo-Greek style :[1] *his long and admiring account of the* Analysis of Beauty *shows that he retained a predilection for the serpentine line.*

Fréron gave L'Etat des Arts *a long and appreciative review in* L'Année Littéraire; *it fills most of his letter for 1 April 1755.* "*La conclusion que l'on tire de l'ouvrage de M.* Rouquet, *c'est qu'il s'en faut de beaucoup que ces Arts ayent atteint à Londres ce point de gloire & de perfection où ils sont parvenus & se soutiennent dans d'autres pays. Les grands Artistes, Anglois de naissance, y sont fort rares, & vous avez remarqué que l'Auteur en cite beaucoup plus d'étrangers que de nationaux. Une exacte impartialité regne dans son livre. Il a sçu se défendre également de l'excès de l'admiration & du mépris. Son style n'est ni correct, ni précis; il a quelques expressions impropres telles qu'*incon-sistance *pour* inconséquence; *malgré cela il se fait lire avec plaisir; on y trouve une certaine force d'esprit, un tour original qui plaît, une sorte de poësie qui amuse. On le voit de temps en temps s'élancer, pour ainsi dire, hors de lui-même, au moment qu'on s'y attend le moins, interrompre sa*

[1] *See S. Eriksen,* "Marigny and Le Goût Grec", *in* Burlington Magazine, *civ, 1962, pp. 96-101.*

marche par de brillantes apostrophes à quelque objet qui lui passe par l'imagination . . .

"*Le talent de M.* Rouquet *est la Peinture en émail, dans laquelle il est supérieur à tous les Peintres de l'Europe qui s'exercent dans ce genre. Il s'est fait admirer au dernier Salon par plusieurs morceaux de sa composition. Il est d'ailleurs homme de beaucoup d'esprit & de bonne société. Genève est sa patrie; ce n'est que depuis quelques années qu'il s'est déterminé à se fixer en France. Il a obtenu à son arrivée à Paris un logement aux Galleries du Louvre. Ce bienfait accordé avant qu'il fût sollicité est le fruit du discernement de M. le Marquis de* Marigny, *& une preuve de l'amour & du zèle éclairés qu'il a pour les Arts. C'est ce qui a occasioné l'Epître dédicatoire que M.* Rouquet *a mise à la tête de son Livre.*"

Perhaps for their own reasons, as we shall see, the Encyclopédistes were not quite so favourable, though obliged to admit the interest of the little book. On 1 August 1755 one of the collaborators in Grimm's Correspondance Littéraire, *either Grimm or Diderot himself, wrote:* "M. Rouquet, *peintre de portraits en émail et de l'Académie royale de peinture, a donné, il y a déjà du temps, une brochure intitulée* L'Etat des arts en Angleterre. *Ce titre pompeux ne déparerait pas l'ouvrage*

*d'un philosophe sur un pareil sujet, qui est cer-
tainement assez important. La brochure de M.
Rouquet n'est qu'une simple indication, plutôt dans
le goût d'une description, comme nous en avons
des curiosités de Paris, que d'une histoire
raisonnée et critique. Cependant il a placé, par ci
par là, des observations utiles et bien faites : il
réprime, en passant, les* Lettres sur les Anglais,
*par M. l'abbé Le Blanc, dont le ton dur et
insolent a toujours déplu aux honnêtes gens." The
writer then takes issue with Rouquet's theory of
portraiture. The painter, he declares, must animate
his canvas and make his portrait express a thought.
Man is always thinking and doing, and always
changing his face and position : the painter must
choose from the variety of attitudes that he offers,
which means showing the sitter engaged in some
momentary activity, physical or mental.*

*Rouquet's impartiality offended on both sides
of the Channel. Mariette drily observes that "on a
trouvé qu'il se montroit trop partisan du génie
anglois." In November 1755 the* Monthly
Review *was equally certain of the contrary. "It
is astonishing, that of all the* French *writers who
have attempted to describe this nation to their
countrymen, not one of the whole number hath
understood us rightly: that, from* Voltaire, *down*

to the gentleman before us, not one of these painters hath hit off a just likeness! We must, certainly, be a very incomprehensible people!

"Mr. Rouquet's table of contents is sufficient to raise a suspicion, that the Author does not even know what is meant by the term Arts. His preliminary discourse is a tedious jumble; and throughout the whole book, his observations are either trifling or false. One would have imagined, that in the space of thirty years, a man of common penetration might have known us better.— That such a book as this should appear at Paris, is not at all surprising, as there are few in that city qualified to detect and refute it; but it is strange such a book should find a translator in England."

The translator of the book has not been identified. His translation is fluent and generally faithful: there is a slip in the account of Hogarth's pictures (p. 27), where it is of course the figures that are seven or eight inches high. In the description of the style we know as Rococo (p. 85), the word baroque is left out, probably deliberately. The dedication to Marigny of the French edition is also omitted. The book cost 2s., and was already scarce in 1823.[1]

[1] E. Hardcastle (W. H. Pyne), Wine and Walnuts, ii, 1823, p. 7. I ignore an obviously apocryphal anecdote recorded by Pyne.

INTRODUCTION

According to bibliographers Rouquet also wrote a book called Les Illustres Angloises, *but I have not traced a copy. In 1755 he joined in a controversy about painting in encaustic wax. The Comte de Caylus, that great* amateur *of the arts, believed that he and his assistant Majault had been the first to rediscover its secrets, lost since antiquity. Unfortunately he had a rival in the painter Jean-Jacques Bachelier, whose methods were advertised by Diderot in an anonymous pamphlet, issued in April 1755, entitled* L'Histoire et le Secret de la Peinture en Cire. *Rouquet examined Bachelier's paintings, and finding them ugly, burlesqued Diderot's pamphlet, also anonymously, in* L'Art Nouveau de la peinture en fromage, ou en ramequin, Inventée pour suivre le louable projet de trouver graduellement des façons de peindre inférieures à celles qui existent. *His little satire was very successful: Mariette calls it* "une des bonnes plaisanteries que je connoisse", *and it was reprinted in 1769. Cochin hints in his* memoires *that Caylus secretly encouraged this and other attacks on his rival: the slightly chilly treatment of Rouquet's book in the* Correspond-dance littéraire *was probably caused by this affair. Besides Rouquet speaks not too kindly of*

philosophers in L'Art Nouveau, *no doubt with an intention against* les philosophes *as a party.*

Rouquet's end was miserable. Mariette, who admits his talent, says that he was withdrawn and disagreeable and so bitterly satirical as often to be offensive. Evidently the tragedy that befell him in France embittered him, perhaps disturbed him psychologically. For in 1753 he was grief-stricken by the death of his dearly-loved wife, Jeanne. He had an attack of apoplexy, but recovered, and appeared to enjoy good mental health until the early spring of 1758, when he became paralysed in one side, and fell into a melancholy at not being able to work. He took a little house at Chaillot to convalesce, but his trusted English housekeeper, who had been with him for some eighteen years, suddenly died, and poor Rouquet became deranged. He returned abruptly to Paris, where he appeared several times in the streets half-naked. He threw bottles and heavy pieces of wood out of his window, and lit fires which alarmed his neighbours for their own safety. No servant would stay with him: he declined to allow the doctors or nurses called by Cochin to treat him and dosed himself so heavily with drugs that the apothecary refused to sell him any more without a physician's prescription. On 17 August 1758 the

INTRODUCTION

lieutenant-général of the Prévosté de l'Hôtel came officially to the Louvre, and took depositions from Cochin and his servant, Silvestre, Chardin, François-Thomas Germain, and Quentin de la Tour. The lieutenant-général found Rouquet dressed in a grey silk coat, without either breeches or stockings. In his logement *were signs of damage from fire. That same day the order was given for him to be confined in the hospital of Charenton until his recovery. He was taken to the hospital on 19 August, and died there on 28 December.*

R. W. Lightbown

BIBLIOGRAPHY

(apart from that cited in text)

For the Abbé Le Blanc, see Hélene Monod-Cassidy, Un voyageur-philosophe au XVIII^e siècle; l'Abbé Jean-Bernard Le Blanc, *Cambridge, U.S.A., 1941 (Harvard Studies in Comparative Literature, XVII).*

Mariette, P. J. Abécédario, v, *1858-9, p. 52.*
Redgrave, S. A dictionary of artists of the English School, *London, 1874, p. 553.*
Guiffrey, J., Scellés et Inventaires d'Artistes, *in* Nouvelles Archives de l'Art Français, *ser. 2, v, 1884, pp. 254-69.*

For the quarrel about encaustic painting see Watelet and Levesque, Dictionnaire des arts, *ii, Paris, 1792, s. v. Encaustique.*
Cochin, Charles-Nicolas, Mémoires inédits, *ed. C. Henry, Paris, 1880, pp. 40-3, 69-70.*

For the captivity of Belle-Isle see Walpole, Letters to Mann, *ed. Lewis, ii, p. 563; iii, pp. 19, 78.*

For Rouquet's miniatures, see the literature cited in C. Brun, Schweizerisches Künstler-Lexikon, *ii, Frauenfeld, 1908, p. 678 and Thieme-Becker,* Allgemeines-Lexikon, *xxix, Leipzig, 1935, p. 111, and the following:*

BIBLIOGRAPHY

Long, B., British miniaturists, *London, 1929, p. 378.*

Reynolds, A. G., English portrait miniatures, *1952.*

Schneeberger, P.-F., Les peintres sur émail genevois au XVII^e et au XVIII^e siècle, *Geneva, 1958, pp. 154-7.*